Handmade
Eyelet
Greetings Cards

Polly Pinder

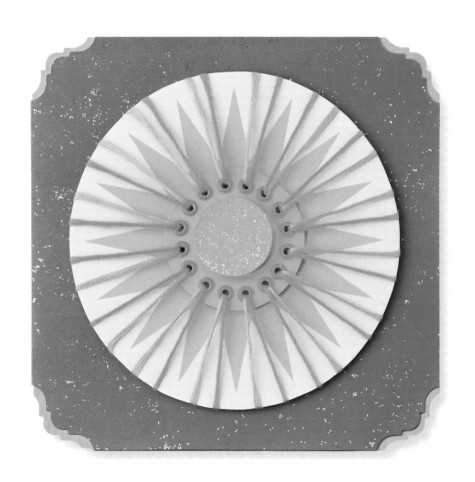

SEARCH PRESS

First published in Great Britain 2005

Search Press Limited
Wellwood, North Farm Road,
Tunbridge Wells, Kent TN2 3DR

Text copyright © Polly Pinder 2005

Photographs by Roddy Paine Photographic Studios

Photographs and design copyright © Search Press Ltd. 2005

ISBN 1 84448 053 4

The Publishers and author can accept no responsibility for any consequences arising from the information, advice or instructions given in this publication.

Suppliers
If you have difficulty in obtaining any of the materials and equipment mentioned in this book, then please visit the Search Press website for details of suppliers:
www.searchpress.com

Alternatively, you can write to the Publishers at the address above, for a current list of stockists, including firms who operate a mail-order service.

Publishers' note
All the step-by-step photographs in this book feature the author, Polly Pinder, demonstrating how to make greetings cards using eyelets. No models have been used.

Manufactured by Universal Graphics Pte Ltd, Singapore

Printed in Malaysia by Times Offset (M) Sdn Bhd

To my dear brother, Christopher, and his new wife, Lucia, wishing them many years of love and happiness.

ACKNOWLEDGEMENTS
I would like to thank Craft Basics of Gillygate, York, for providing all the eyelets and eyelet tools used in the making of the cards in this book.

Cover
Sunflower
Eyelets are used to represent the seeds in the centre of this sunflower. The patterned leaves were cut from an old seed catalogue and the yellow card for the petals was put through a crimping machine. This gave a subtly different direction to each petal.

Page 1
Sunburst
Three layered discs, each raised by 3D foam squares, are used to create this sun. Embroidery silk in yellow and orange is threaded through eyelets to create some of the rays.

Opposite
Dizzy Heights
An orange eyelet was used to attach four layers of fringed mulberry paper to create this lofty flower.

Contents

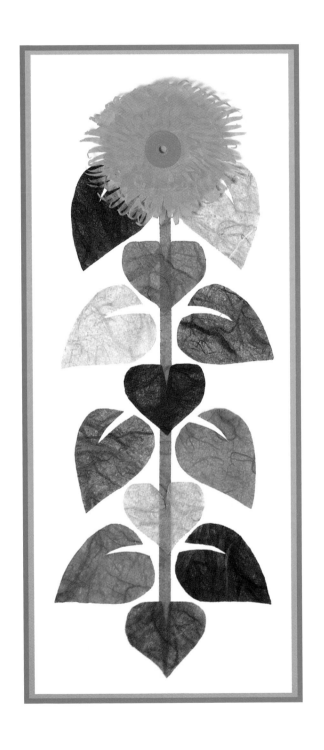

Introduction

Eyelets were a lovely surprise for me. Having used them years ago in the making of belts and children's gym bags, I never thought that they would become part of the card maker's kit.

We card makers are always looking for innovative ideas to embellish our cards and eyelets certainly fulfil that brief. Made from aluminium, they can be practical, decorative or both. It is difficult to believe that something which requires a thoroughly good hammering can ultimately produce a very delicate and intricate design. The manufacturers have designed additional pieces which lie between the paper and the eyelet, representing anything from a Christmas tree to an open hand, an apple, a snowflake or even a tiny birthday cake with candles. These, combined with the variety of papers and card now available, add a fascinating new dimension to card making.

My daughter, in passing, said that she thought handmade cards were little works of art in themselves, and I believe she is right. Time, patience and love go into each one and that is why the recipient always treasures them. As your cards become ever more professional, whether you are making them to send to friends and relations or to sell at a charity fair, do remember to put your name somewhere discreetly so that people appreciate your talents.

I hope you will follow some of the designs in this book and that they will prove an inspiration for you to develop new eyelet ideas of your own.

Polly

Opposite

Flowers are a natural subject for eyelets but they can be put to any number of uses to develop and enhance a design.

4

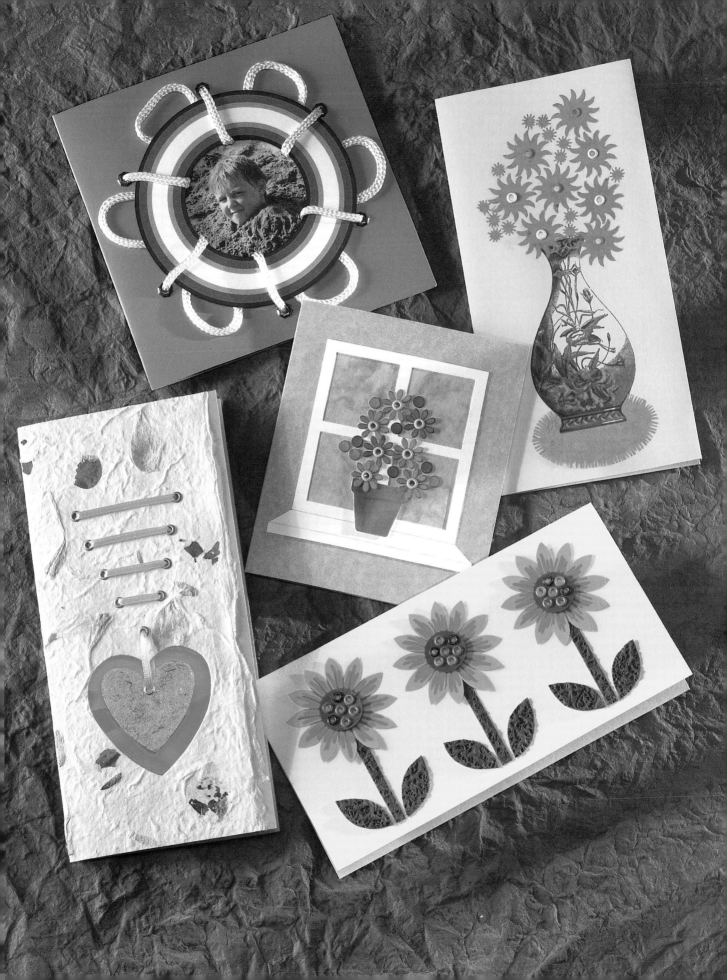

Materials

Cards and papers

The range of wonderful cards and papers available to card makers seems to increase yearly, which is great. The card needs to be firm enough to stand on its own when folded. Despite all the hammering required to secure eyelets, they do not seem to distort the card at all. If you like a particular paper, perhaps a mulberry tissue paper or a beautiful handmade paper which lacks the strength to stand on its own, simply glue it on to card. Cut it large enough to make a neat, parallel border going over the fold of the card and on to the back.

Quality magazines are also a good source of paper, but the paper must not be so thin that printed images can be seen through from the back when it is glued down. I have used garden magazines, antique and interior design magazines and seed catalogues for the cards in this book.

The insides of old envelopes were used to create the variety of patterned flowers on page 15 and gift wrap was used for the background of the Family Album card on page 27 and the Rays of Sunshine card on page 45.

Wallpaper is also very useful. The textured types can be painted with acrylic paint to fit into your colour scheme. I used some for the fluffy-looking clouds on page 47.

No matter how tight your budget, in our throw-away society there are always plenty of papers that we card makers can recycle.

Eyelets and eyelet tool kit

The eyelet tool kit comprises sturdy piercing tools in different sizes to make the initial hole, an equally sturdy setting tool for pressing the eyelet into the card, a hammer and a cutting mat. Sometimes the piercing tool and setting tool are interchangeable heads which screw into a single handle. These components can be bought separately or as a combined kit. You can buy an eyelet setting mat, but I use an ordinary cutting mat.

 Eyelets come in a wide range of colours but if your chosen colour is not within the range, you can always paint them using acrylic paints, tint them with felt-tipped markers or even use nail varnish to achieve a pearlescent effect. You could also dab on a little varnish, then dust the eyelets with fine glitter. If you are making changes to the colour, secure the eyelets in adhesive putty while working on them.

A hammer with piercing and setting tools for attaching eyelets.

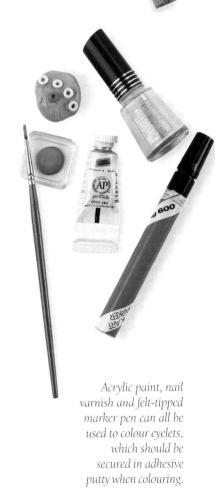

Acrylic paint, nail varnish and felt-tipped marker pen can all be used to colour eyelets, which should be secured in adhesive putty when colouring.

Embellishments

You will need a variety of threads and cords. The glittery, metallic embroidery threads are particularly useful; they come in different thicknesses and shades of gold and silver. The plain, brightly coloured embroidery silks and narrow ribbons are also very useful.

Rubber stamps and embossing powder add another aspect to your card design, as do felt-tipped and gel pens.

You will need photographs if you are going to make some of the Family Album cards.

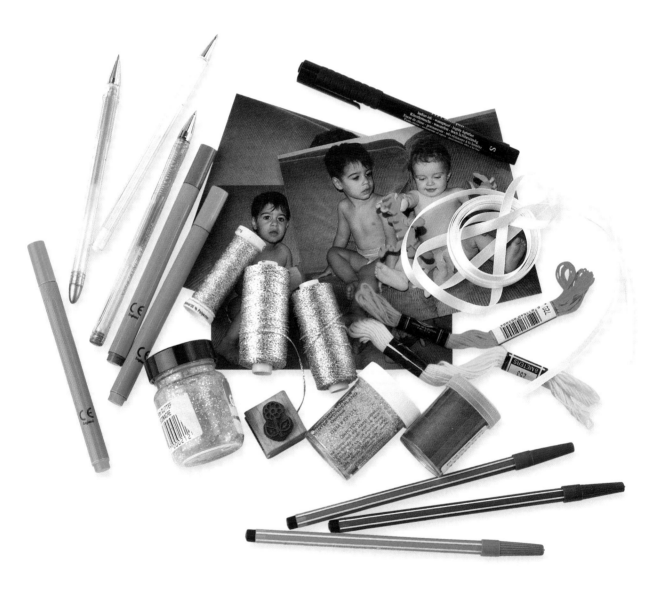

Felt-tipped pens, gel pens, photographs, a permanent marker, ribbon, embroidery silks, metallic threads, embossing powder, a rubber stamp and glitter.

Other materials

Cutting implements and accessories You will need a pair of sharp scissors and a good quality craft knife with spare blades. I prefer to use a knife with a strong, steel handle. A circle aperture cutter (rather like compasses with a blade) or curved cuticle scissors are very useful for cutting out circles. A self-healing cutting mat is very important, and you will also need a steel ruler. Decorative craft punches and fancy-edged scissors are invaluable accessories for the card maker.

Glues and sticky tapes I have used glue stick, clear all-purpose glue, ordinary sticky tape, double-sided tape and 3D foam squares.

Drawing materials Tracing paper is necessary for transferring the templates in the book on to your card or paper. You will need an HB pencil and, if the paper is dark, a white pencil. A sharpener and an eraser will be useful. You may also need a pair of compasses or a circle template.

Crimping machine This is used to give a crimped, three-dimensional effect to flat paper. It is useful for adding another texture to your card.

Knitting needle If you are making your own cards, the best implement for scoring prior to folding is a knitting needle. Simply pull it down against your ruler as if you were drawing a line.

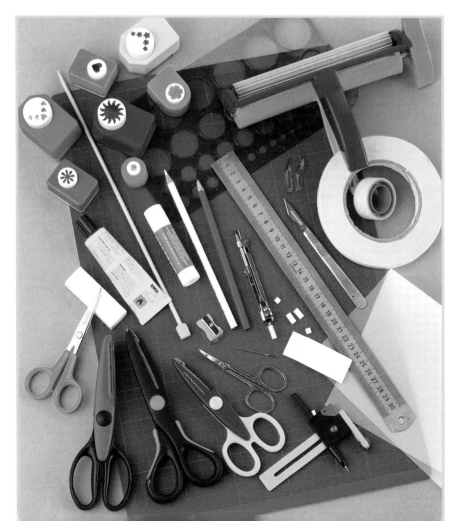

Clockwise from top left: craft punches, circle template, crimping machine, double-sided tape and sticky tape, craft knife and blades, metal ruler, 3D foam squares, tracing paper, compasses, fancy-edged craft scissors, cuticle scissors, darning needle for threading ribbon, paper scissors, eraser, all-purpose glue, glue stick, white pencil, HB pencil, circle aperture cutter, pencil sharpener, knitting needle, self-healing cutting mat.

Basic techniques

Eyelets could not be simpler to use and you can always release any pent-up frustration by using the hammer! Be sure to buy the correct sized tools to match your eyelets; if the piercing tool is too large, the set eyelet will not have sufficient grip on the card and the eyelet will fall through.

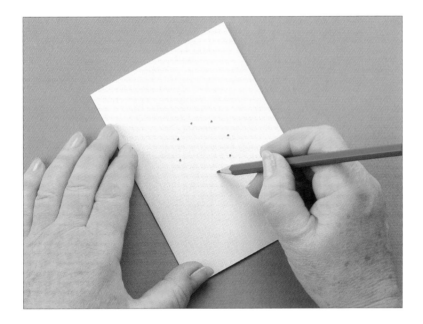

1. Mark where the eyelets will be on your card.

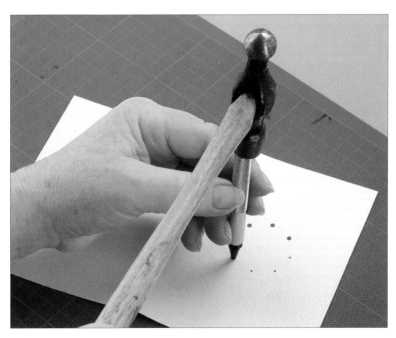

2. Always work on a cutting or setting mat when attaching eyelets. Open the card flat, hold the piercing tool on one of the marks and hammer. One blow should be enough.

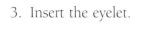

3. Insert the eyelet.

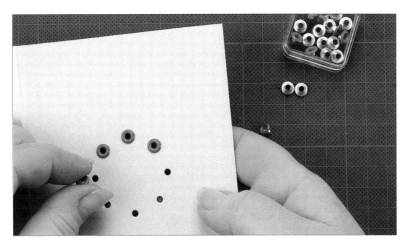

4. Turn the card over and insert the setting tool. One or two knocks with the hammer will curl the tube of the eyelet and press it into the card.

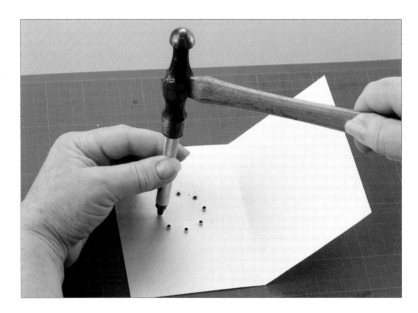

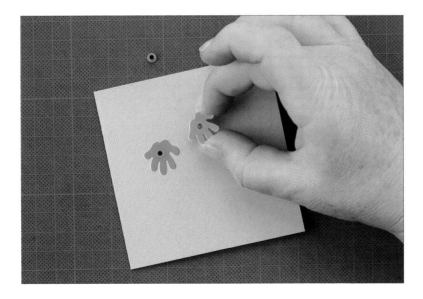

If the eyelet has a decorative piece, lay this over the punched hole before inserting the eyelet.

Floral Glory

Most card makers hoard anything remotely interesting that could enhance their cards or add a touch of originality. The little flowers for this card were punched from used envelopes. Many years ago someone decided to print a simple repeating pattern on the inside of envelopes, to make it impossible to decipher the contents of any letter inside. How useful for us! There are many different patterns which look lovely in an arrangement with plain coloured eyelets of a similar shape.

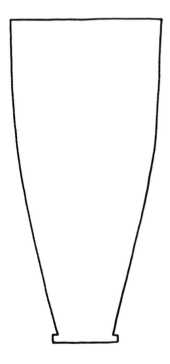

The template for the vase, shown full size.

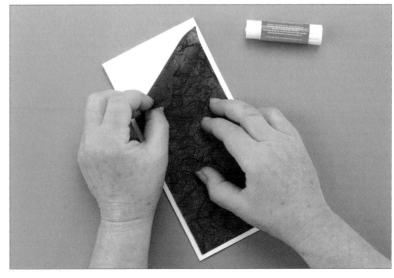

1. Carefully apply glue stick to one side of the mulberry tissue. Stick the tissue paper on to the card, leaving a neat border all the way round.

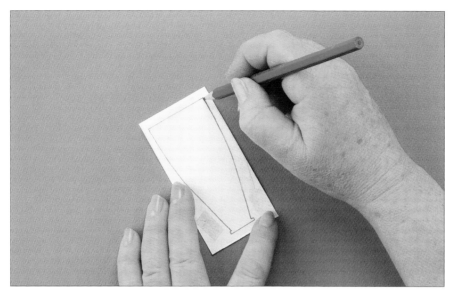

2. Transfer the vase template on to the cream card using tracing paper and a pencil.

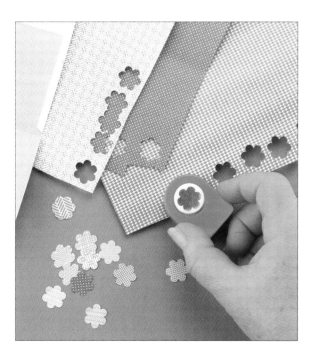

3. Punch fifteen flowers with a variety of patterns from your used envelopes.

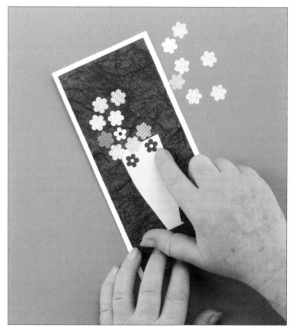

4. Cut out the cream vase shape and stick it on to your main card, 32mm (1¼in) from the bottom edge, using glue stick. Arrange the paper flowers and flower eyelets. Place the two blue flower eyelets on the vase so that they are not lost on the dark background.

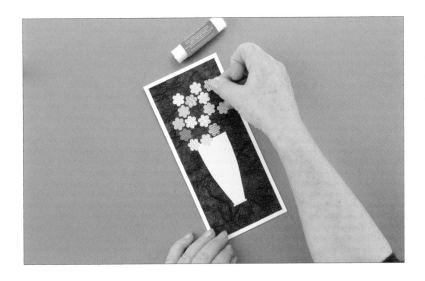

5. When you are happy with the arrangement, remove one paper flower at a time and stick it down using the glue stick.

6. Using the white pencil, mark the centre of each cream flower eyelet. Repeat with the blue flower eyelets using the graphite pencil. Remove the flowers, open the card and, working on the cutting mat, make holes with the eyelet piercing tool over each mark. Make holes for the little cream eyelets in the centre of some of the paper flowers.

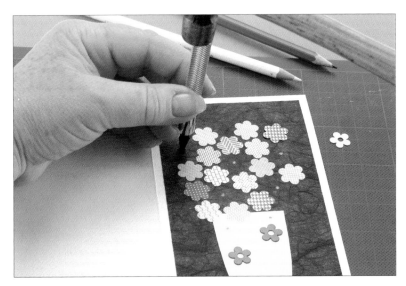

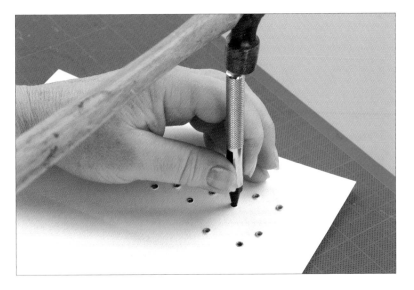

7. Position the flowers and push the eyelets through. Turn the card over and, using the setting tool and hammer, set all the eyelets.

Opposite

The finished card. These little flower eyelets, which have a slight sheen, contrast beautifully with the patterned matt finish of the envelope flowers.

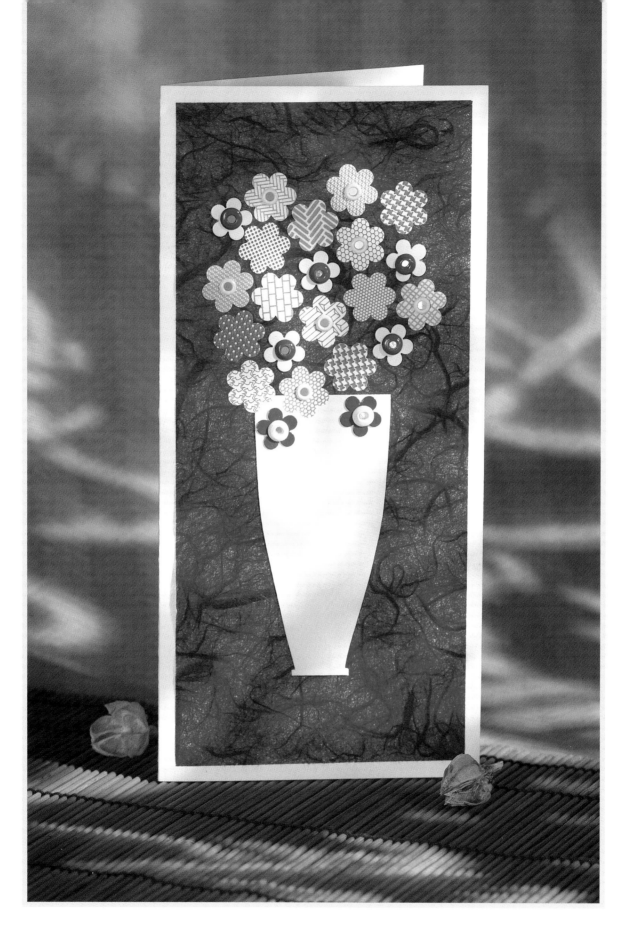

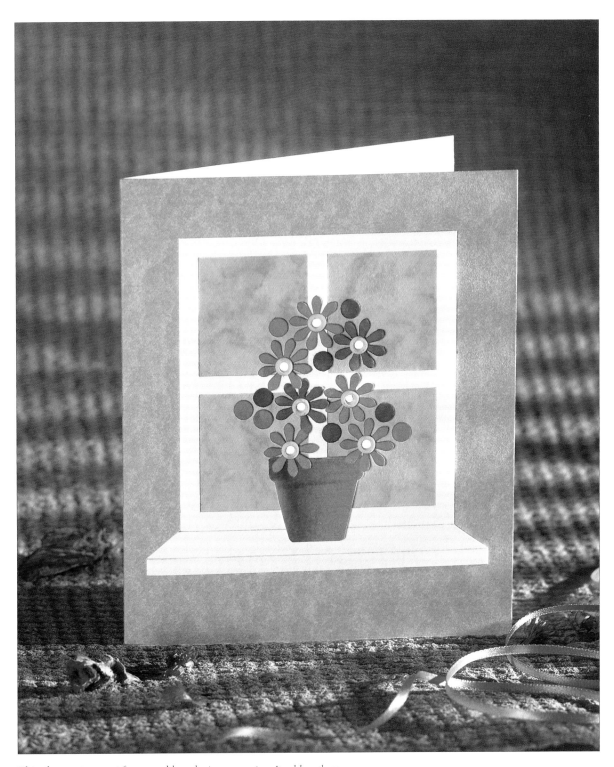

This plant pot was cut from an old gardening magazine. It adds a three-dimensional effect to the design. The flowers were cut with craft punches, the 'buds' with an office hole punch.

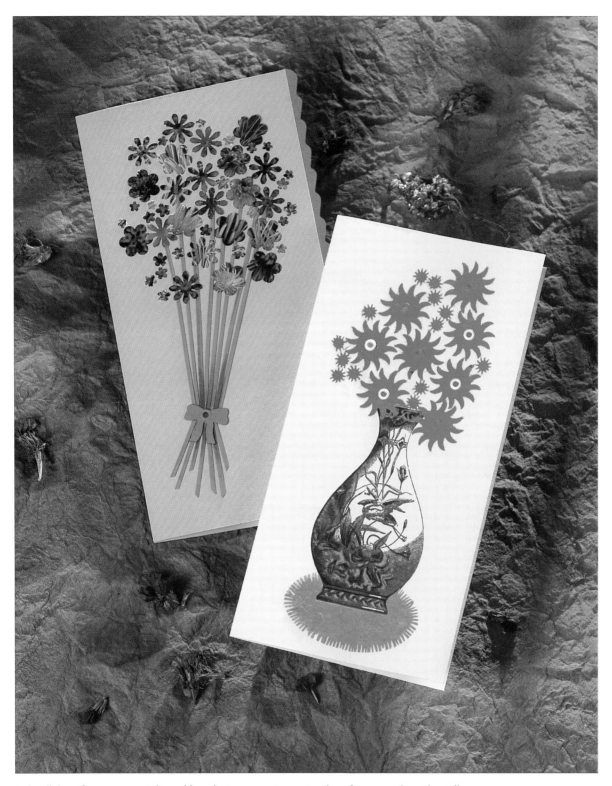

Left: All these flowers were cut from old gardening magazines using three flower punches. The stalks were cut from green card and coloured with a green felt-tipped pen to give slight variation. Right: The purple vase was scanned from an old magazine, then coloured on the computer. The flower heads, cut with a craft punch, and fringed mat are made from handmade Indian tissue paper.

Heart of Gold

Cut-outs add another dimension to the greetings card. If you haven't used a craft knife for this purpose before, practise on some spare card first. When making internal cuts, the knife really is much easier than scissors.

A heart of gold implies generosity of spirit, so this card need not be restricted to sending only to one's partner – a friend or relation who has shown great kindness would appreciate the sentiment just as much. Should you wish to, there is space in the right-hand corner to write, diagonally in gold, 'Heart of Gold' or simply 'Thank you'. The crinkled foil paper can be bought from most craft shops.

You will need

Cream card blank, 140mm (5½in) square

Cream card, 120 x 135mm (4¾ x 5¼in)

Crinkled gold foil, 100mm (4in) square

Knitting needle and ruler

Craft knife, cutting mat, metal ruler and scissors

Tracing paper and pencil

Eyelet tool kit

One small, plain eyelet and four gold heart-shaped eyelets

Ivory ribbon, 6 x 500mm (¼ x 20in) and darning needle

Clear all-purpose glue and double-sided tape

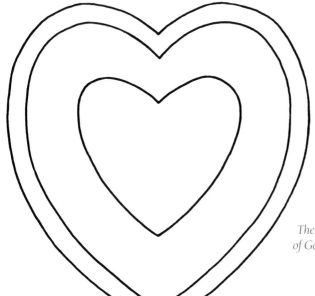

The template for the Heart of Gold card, shown full size

1. Measure 15mm (⅝in) from the fold of the card blank. Position your ruler and score a line parallel to the fold using the knitting needle.

18

2. Trace the three hearts from the template. Position the tracing paper in the centre of the open card (excluding the indented border) and transfer the hearts design. Using a craft knife and cutting mat, carefully cut out the largest heart. Transfer the largest heart again on to the centre of the single piece of cream card.

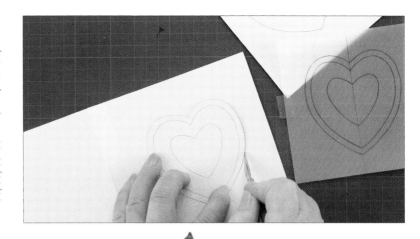

Tip
Crinkled foil is prone to distort. When using a template to cut round, press down very firmly, especially at the edges, and have a really sharp blade in your craft knife.

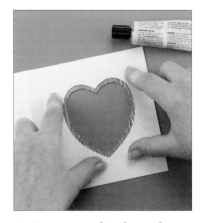

3. Take the triple heart cut from the card blank. Using the craft knife or scissors, cut away to the second heart. Use this as a template to carefully cut out a heart from the crinkled foil.

4. Squeeze a thin line of clear glue round the front of the square of crinkled foil, avoiding the edge of the heart-shaped aperture. Carefully but firmly, press the front of the opened card blank on to the foil.

5. Turn the cream heart over, pencil side down. Glue the foil heart across it so that the crinkles are in the opposite direction to the inlay heart (shown in step 4). Turn the glued heart over and cut out the inner heart shape.

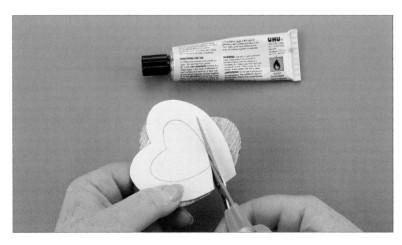

19

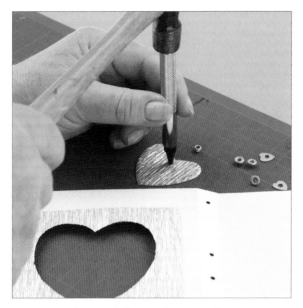

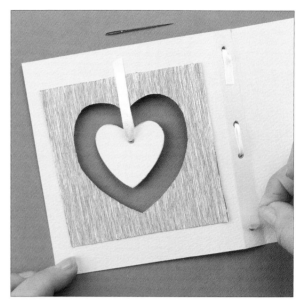

6. Open the card flat and, using the piercing tool and hammer, punch four holes along the indented border. Punch a hole in the small foiled heart in the same way. Insert the small eyelet and set it. Insert the heart-shaped eyelets in the holes in the indented border and set them.

7. Thread 90mm (3½in) of the ivory ribbon through the eyelet in the small heart and glue the ends to the front and inside front of the card so that the heart is suspended in the aperture. Using the darning needle, thread 160mm (6¼in) of the ribbon through the border eyelets. Secure it at the back with small pieces of double-sided tape.

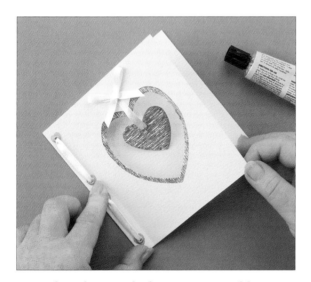

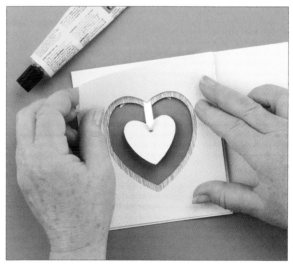

8. Make a bow with the remaining ribbon and attach it using double-sided tape. Run a trail of glue along the inside of the indented border, avoiding the eyelet holes. Press firmly to create a wide spine to the card.

9. When the glue has dried, cut out the large heart shape from the piece of single card and stick it inside the main card to cover the raw edges of the ribbon and foil square.

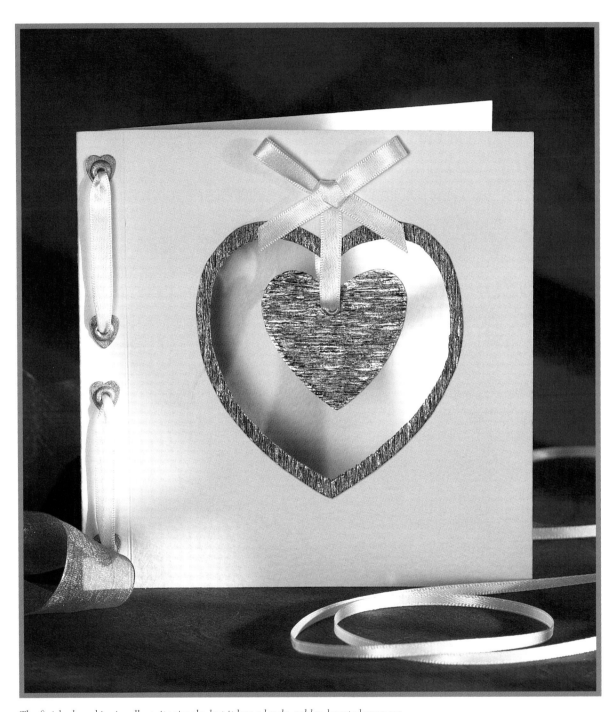

The finished card is visually quite simple, but it has a lovely, golden-hearted message.

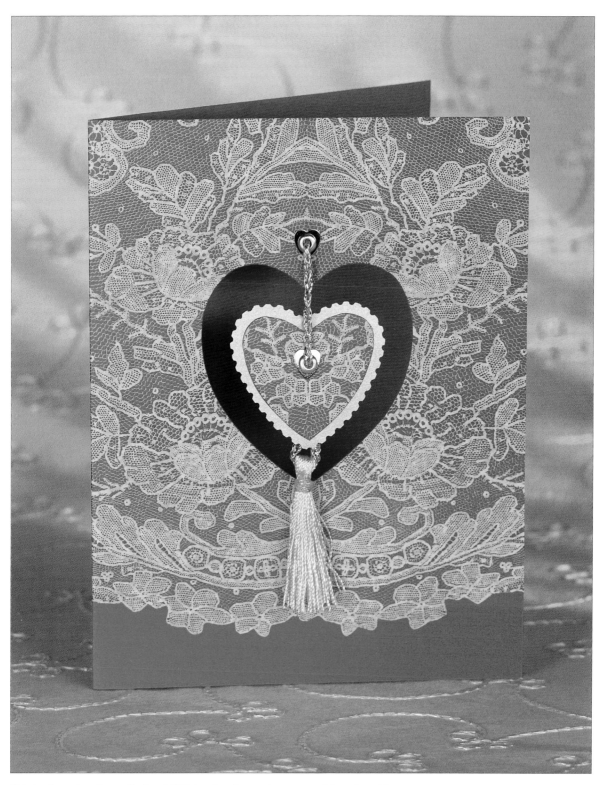

This lovely antique lace veil, circa 1870, is printed on to tissue paper. I found an old paper file almost the same colour, made the card from it and then glued the tissue paper on, leaving the card exposed at the bottom. The tissue paper is available from craft shops but you could try scanning a piece of lace to get a similar effect.

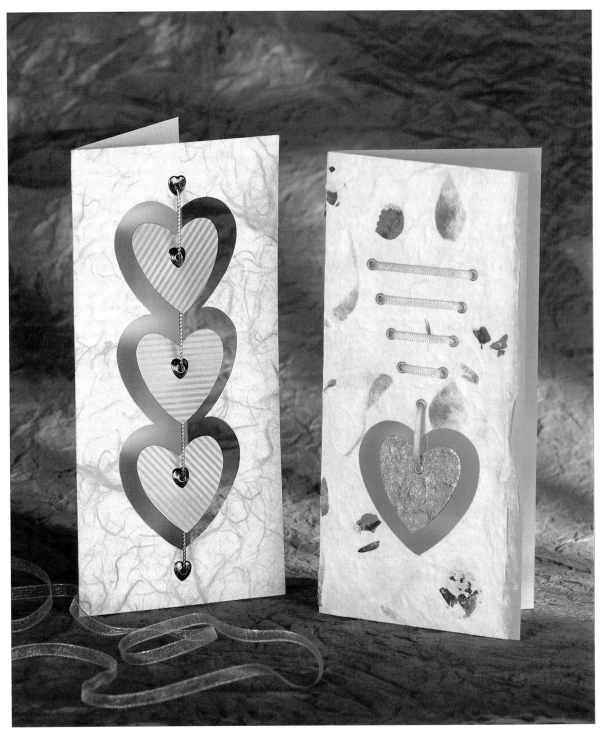

Left: I traced three hearts, slightly overlapping, to make the cut-out shape. The little gold hearts, each cut from striped card at different angles, are strung with gold elastic which is secured at the back with sticky tape.

Right: Handmade paper, incorporating rose petals and leaves, makes a pretty background for threaded ribbon. The little suspended heart was made from the cut-out shape and painted gold to match the eyelets.

Family Album

I found a photograph of an ornate gilt frame in an old magazine dedicated to collecting antiques, and thought it would be ideal for an emailed photograph of two little cousins; my youngest grandchildren. The size of your card will be entirely dependent on the size of your frame. For this reason the 'You will need' list does not include sizes of card, paper, frame or photograph. However, to give you an idea of scale, this card is 180 x 210mm (7 x 8¼in). I have used a small print gift wrap as 'wallpaper' and an old brass chain to 'hang' the picture. Framed photographs of children make lovely surprise cards for their parents.

Tip
You can always reduce or enlarge the size of your picture frame if you have access to a computer scanner.

You will need
Piece of small print gift wrap

Card blank

Photograph of ornate gilt frame, original or scanned

Piece of card slightly larger than the frame

Photograph

Felt-tipped pen in a similar colour to the frame

Square eyelet and eyelet tool kit

Inexpensive chain and old scissors

Craft knife, cutting mat and metal ruler

3D foam squares

Glue stick, clear all-purpose glue and sticky tape

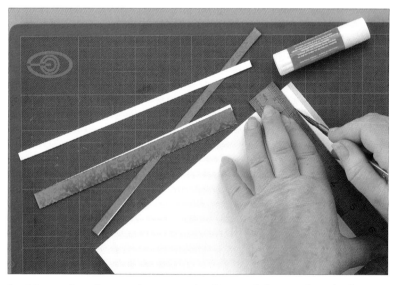

1. Using the glue stick, cover the front of the card with the gift wrap, overlapping a little round the back. If necessary, trim the edges of the card to neaten them.

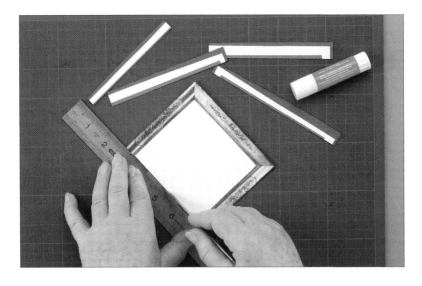

2. Glue the piece of card to the back of the frame, using glue stick. Trim the edges and then carefully cut out the middle.

3. Draw round the inside and outside edges of the frame with the felt-tipped pen. This gives the frame a more authentic look, rather than having white edges.

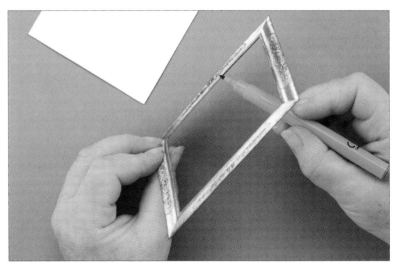

4. Lay the frame over the photograph in order to decide which area you want to be framed. Trim the photograph accordingly then stick it on to the card.

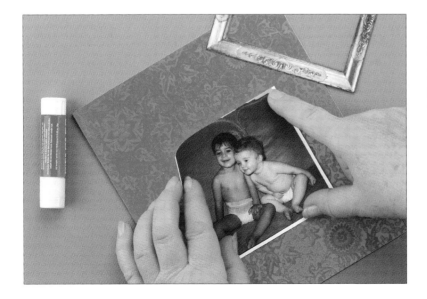

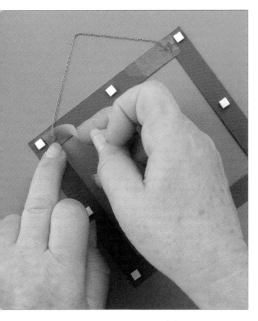

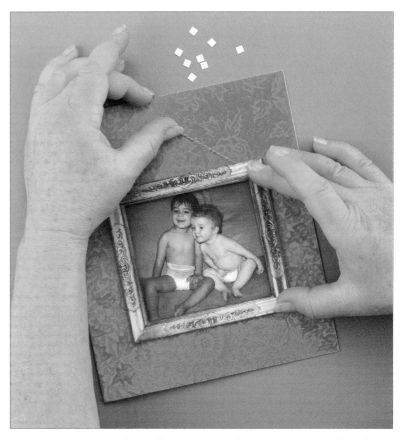

5. Using your old scissors, cut the chain to a suitable length. Attach eight 3D foam squares to the back of the frame. Attach the chain to the top bar of the frame using a dot of glue on each side. Leave the glue to dry, then cover each side with a neat piece of sticky tape.

6. Remove the backing from the 3D foam squares and stick the frame down on your 'wallpapered' card.

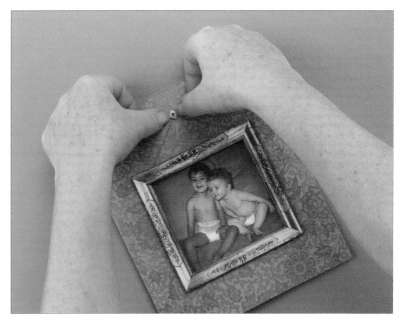

7. Position the chain and mark the centre for the eyelet. Open the card flat and make a hole using the eyelet piercing tool, hammer and cutting mat. Insert the eyelet, making sure the chain is caught. Turn the card over and set it using the setting tool and hammer.

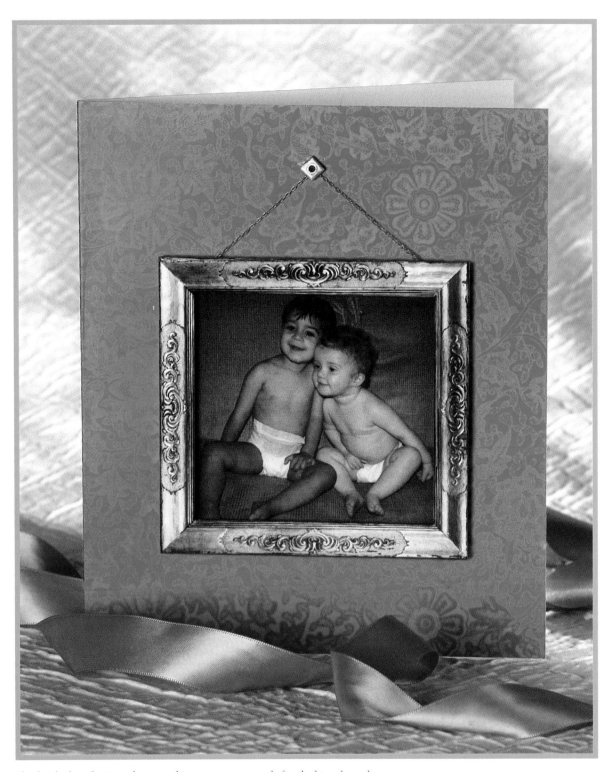

The finished card. Never throw quality magazines away before looking through them for any possible card embellishments. This frame was cut from an old antiques magazine.

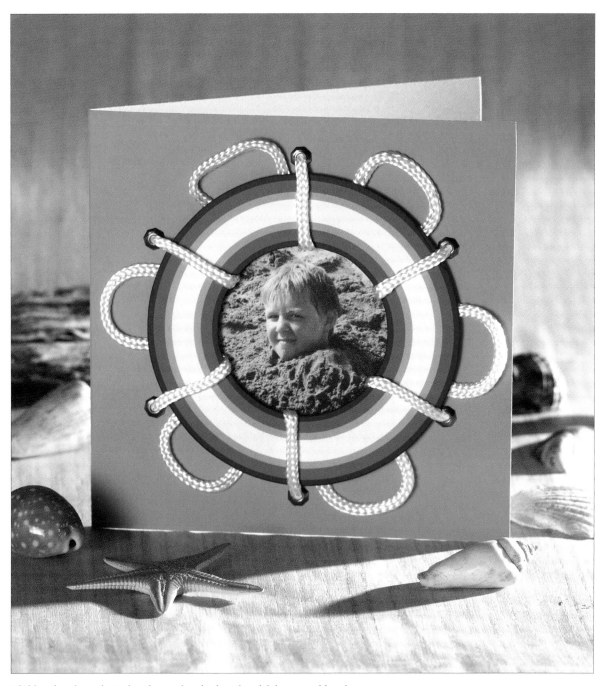

Children love being buried in the sand and I thought a life buoy would make an appropriate frame for this snap of my grandson. The cord handles are stuck separately to the back of the buoy, which is held in place by a length of cord threaded through the eyelets and six holes concealed by the frame.

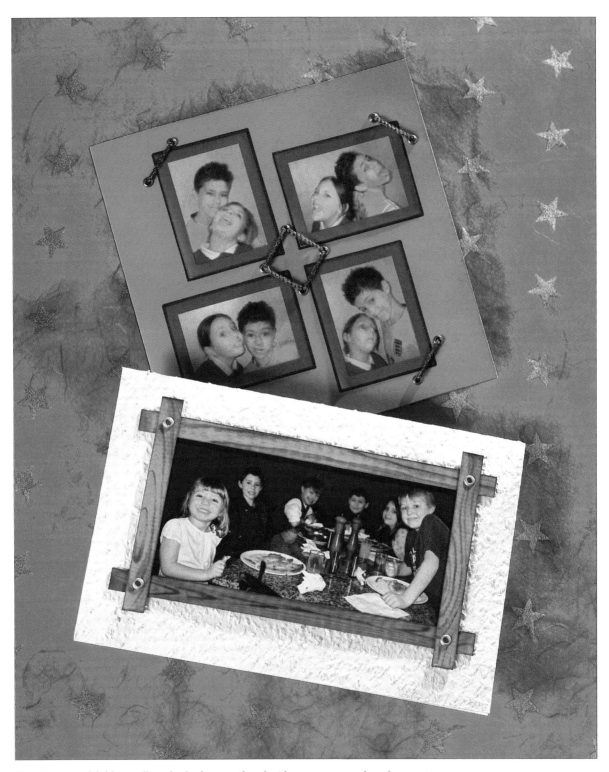

Top: More grandchildren pulling cheeky faces, as they do. There are any number of interesting arrangements for little snaps like these. The string and eyelets are merely decorative here, as the photographs are secured with glue. Bottom: The strips of wood for this frame were taken from a picture of a wardrobe found in a magazine. I scanned the picture, enlarged areas of it then cut the strips and arranged them round the photograph, which shows my grandchildren enjoying a pizza.

Sunflower

Eyelets make perfect centres for sunflowers; they can graphically represent all those hundreds of seeds. This design is a simple concept; the interest lies in the contrast between the large, bright yellow petals and the smaller patterned leaves, cut from an old seed catalogue. Having drawn the petals at different angles, the yellow card was then put through a crimping machine. This gave a subtly different direction to each petal.

You will need

Tracing paper and pencil

Orange card blank,
140 x 190mm (5½ x 7½in)

Yellow card 130 x 200mm
(5 x 8in)

Brown card 70mm
(3in) square

Two strips of pale green paper
20 x 150mm (¾ x 6in)

Old seed catalogues for varied
leaf patterns

Fine black felt-tipped pen

Crimping machine

Compasses

Twenty-one gold coloured
eyelets and eyelet tool kit

Craft knife, cutting mat and
metal ruler

Circle aperture cutter and
scissors

Clear all-purpose glue and
glue stick

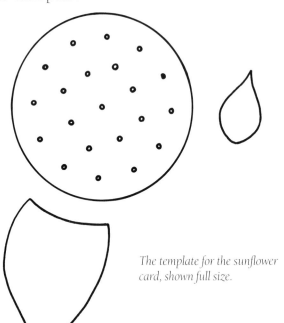

*The template for the sunflower
card, shown full size.*

1. Transfer twelve petals at different angles on to the yellow card. Put the card through the crimping machine, then cut the petals out.

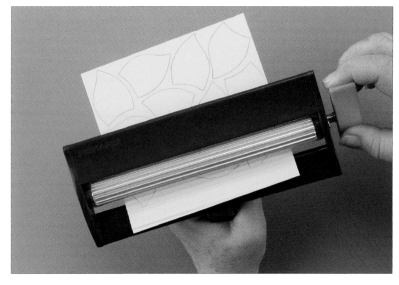

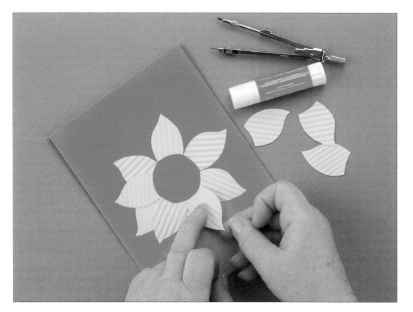

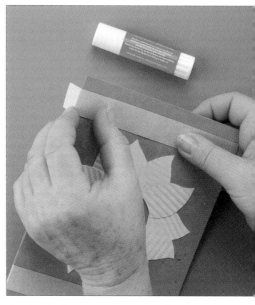

2. Draw a circle in the centre of the orange card blank, slightly smaller than the flower centre (see template).

3. Stick the green strips of paper on to the card 10mm (³/₈in) from the top and bottom edges. Bend the overlap round the back to give a neat finish to the fold of the card.

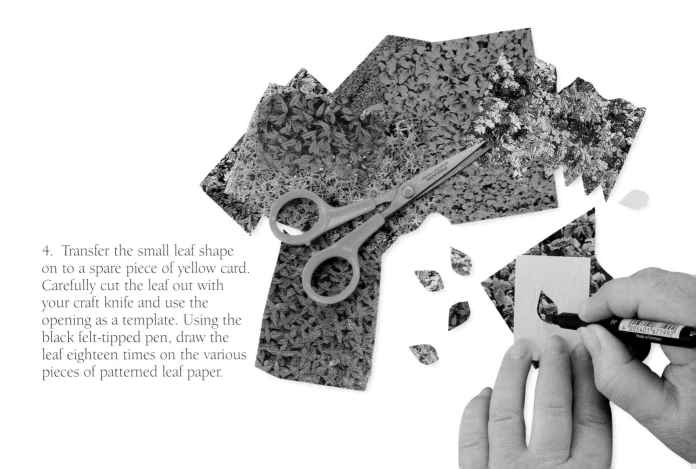

4. Transfer the small leaf shape on to a spare piece of yellow card. Carefully cut the leaf out with your craft knife and use the opening as a template. Using the black felt-tipped pen, draw the leaf eighteen times on the various pieces of patterned leaf paper.

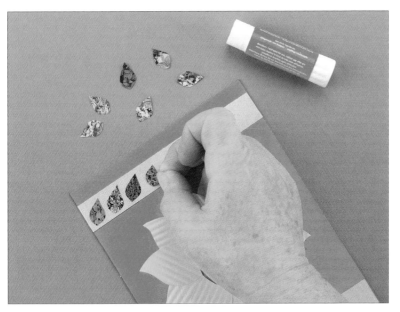

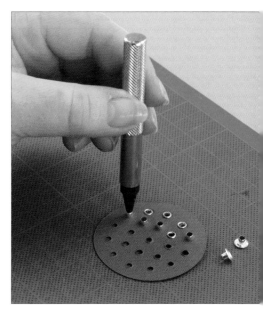

5. Cut the leaves out, cutting away the black pen line. Arrange the leaves on the green strips, the nine on the top strip pointing in the opposite direction to those on the bottom strip. Stick them down using glue stick.

6. Transfer the circle, including the dots, on to brown card, then carefully cut it out (use your circle aperture cutter if you have one). Use the eyelet piercing tool to make holes as indicated by the dots. Put the eyelets through the holes and set them.

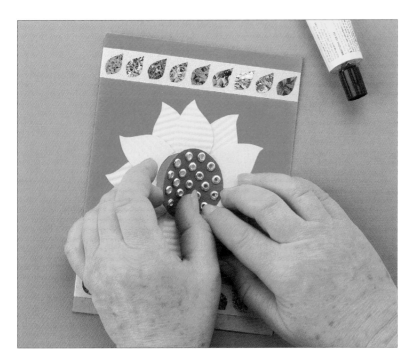

7. Run a line of clear glue round the underside of the flower centre, then position it to cover the inner edges of the petals.

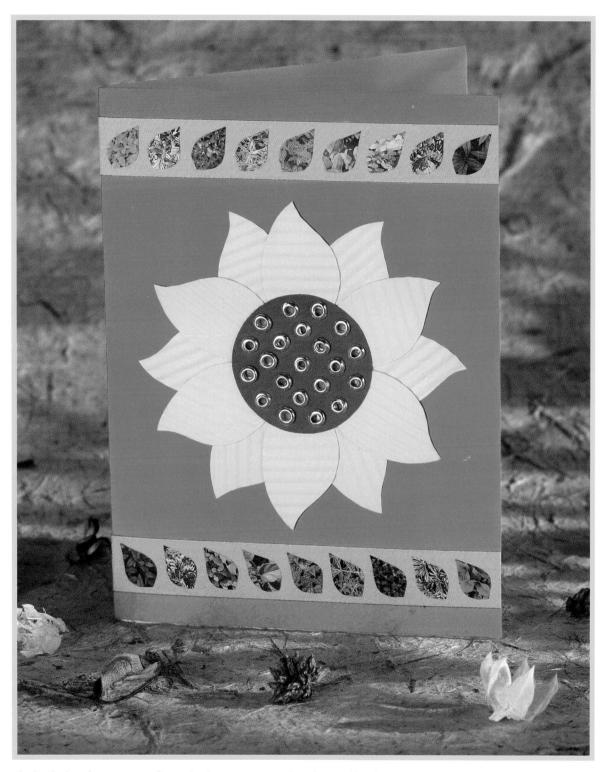

The finished card. Growing sunflowers has become very popular. This would make a nice 'congratulations' card when someone's sunflower has reached dizzy heights, as they often do! It would also make a great card for someone with a summer birthday.

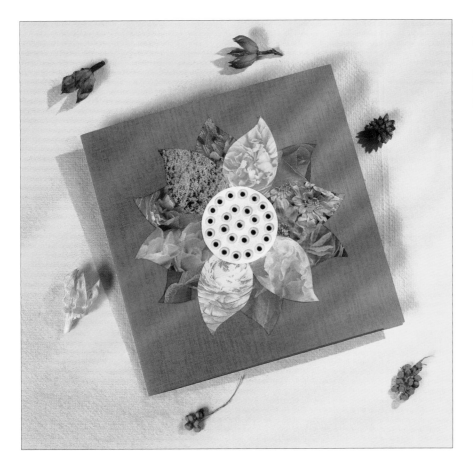

The eyelets for this flower have been painted and arranged differently. The petals have been cut from old seed catalogues, like the leaves on the project card.

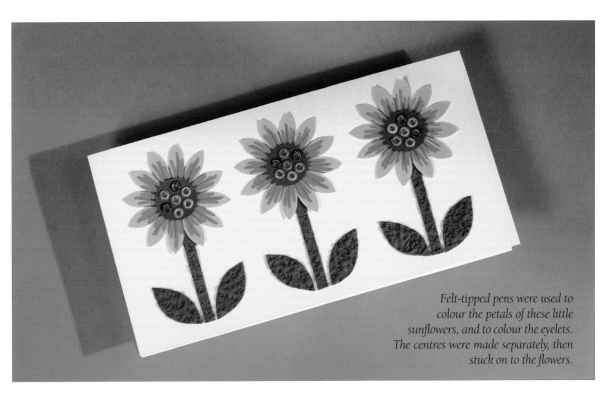

Felt-tipped pens were used to colour the petals of these little sunflowers, and to colour the eyelets. The centres were made separately, then stuck on to the flowers.

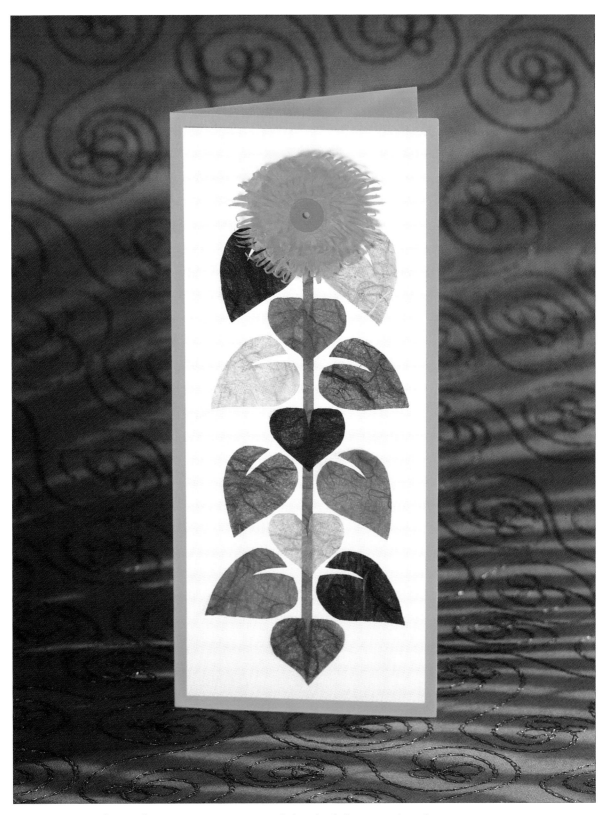

This flower was cut from mulberry paper – tissue paper with threads of silk running through it.
The round eyelet secures four circles with finely cut edges.

Seasonal Trees

Here is an opportunity to do some scribbling and to use your own hand-cut stencil. It is easy to cut the curved lines for the stencil with your craft knife, but don't attempt using scissors. This might be an appropriate card for someone with an autumn birthday.

You will need

Orange card blank, folded A4

Blue card, 132 x 190mm (5¼ x 7½in)

Card for stencils, 132 x 190mm (5¼ x 7½in)

HB pencil and tracing paper

Craft knife and cutting mat

Felt-tipped pens: orange, brown, grey and red

Five gold and four red holed leaf shapes, nine orange eyelets and eyelet tool kit

Glue stick and sticky tape

The template for the seasonal trees card, shown full size.

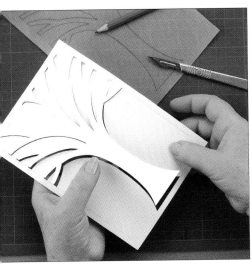

1. Transfer the tree design shown opposite on to card. Using your cutting mat and craft knife, cut the tree out to make a stencil.

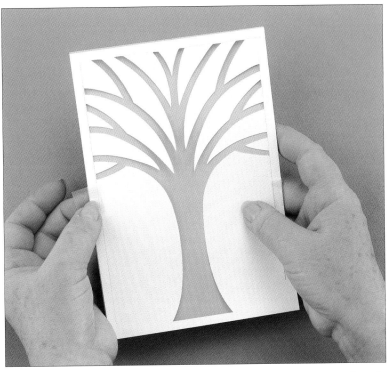

2. Lay the stencil on the blue card. Secure it with a couple of pieces of sticky tape.

Tip

When using sticky tape to secure tracings or stencils, first rub the tape up and down on the edge of your work surface to remove some of the stickiness. This will prevent damage to your card.

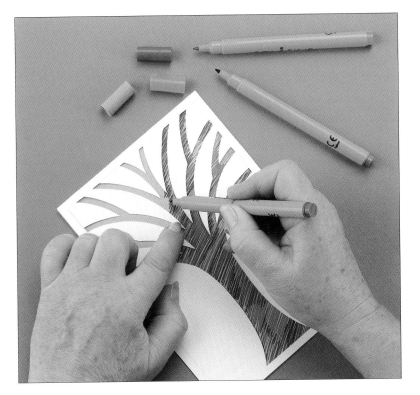

3. Use the orange, grey and brown pens to scribble diagonally on to the card. Hold the points of the stencil down while scribbling to prevent movement.

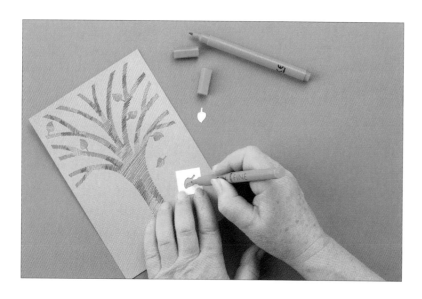

4. Draw round one of the eyelet leaves on to the small piece of card. Carefully cut the leaf out using your craft knife and use the card as a stencil. With the red and orange pens, scribble five leaves on the tree and five leaves falling.

5. Position the red and gold leaf shapes, then use a pencil to mark where the holes will be punched. Make the holes using the eyelet piercing tool and hammer. Reposition the leaves, insert the orange eyelets and set them.

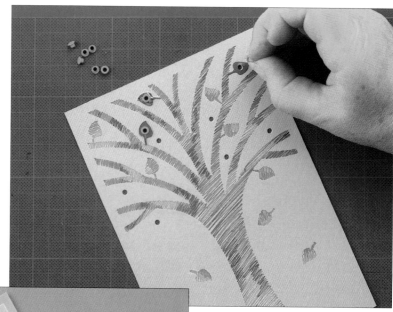

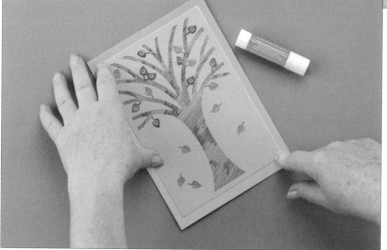

6. Position the blue card on the orange card blank, leaving a slightly deeper orange border at the bottom. Secure using glue stick.

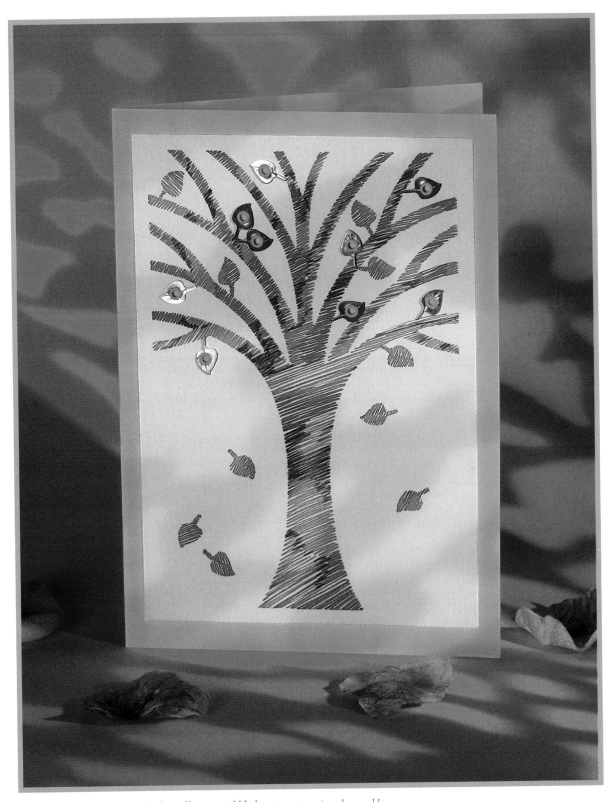

The finished card. This simple but effective scribbled autumn tree is enhanced by the use of red and gold eyelet shapes.

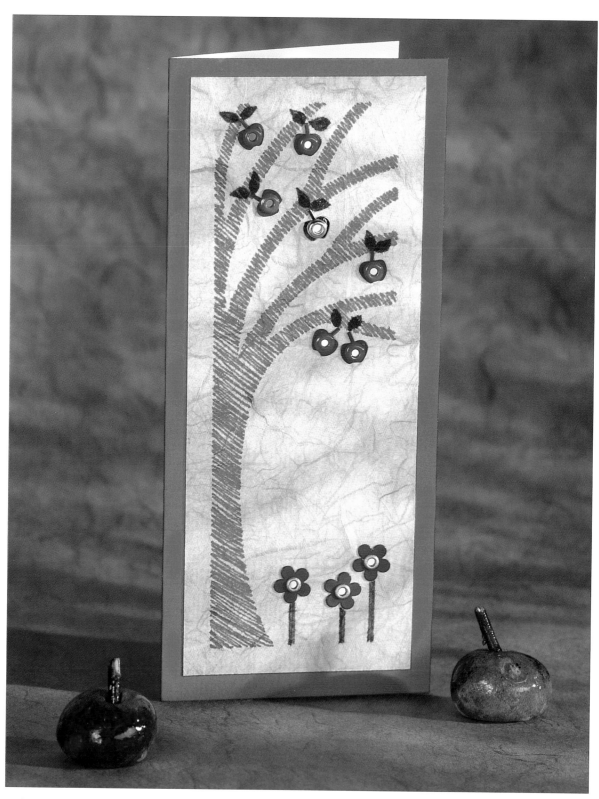

Only half the stencil was used for this card – a strip of card was stuck underneath at the halfway mark to restrict the scribbles. Red and green felt-tipped pens were used; the leaves and flower stems were drawn in after the apple and flower eyelets had been secured.

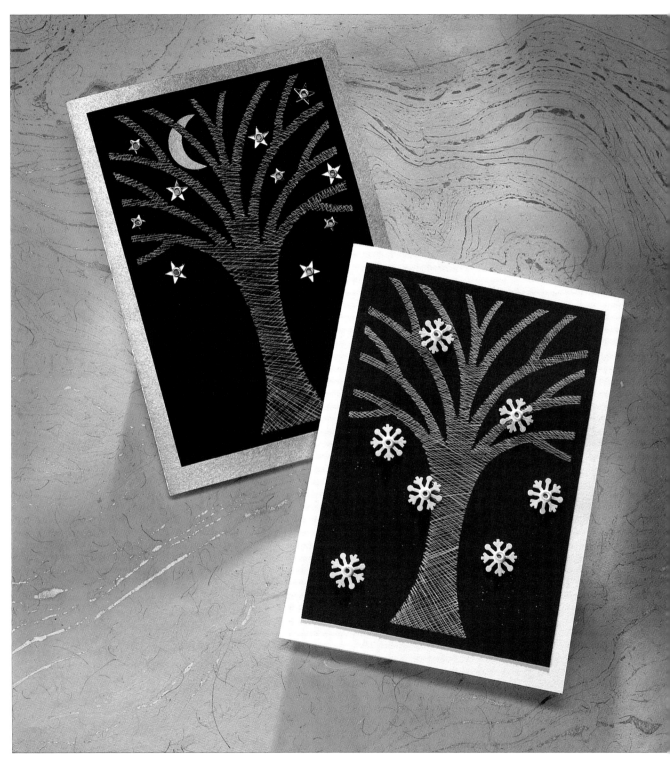

Left: Here cross-hatching has been used; first a gold roller pen was scribbled in one direction, then a silver one in the opposite direction. Two types of star eyelet were secured, then a paper silver moon was cut and stuck on either side of a branch.

Right: A gentle dusting of fine glitter gives a Christmas feel to this simple snowflake design. A fine white roller pen was used for the cross-hatching of the tree.

Rays of Sunshine

The sun is usually associated with all things positive and has been used as a symbol of life-giving force in many cultures. It gives light and warmth and transforms tiny seeds into wondrous plants. Anyone receiving a card with an image of the sun can't help but be cheered up. This card uses a floral paper as a background with each sun ray shining on to a flower eyelet. Try to choose an eyelet colour which links with the background flowers and, as suggested before, you can always paint the eyelets if you cannot buy the required colour. The sun is made from crinkled foil paper, which is wonderful because light plays with the texture and gives depth and contrast to the shape. However, it is not stable and will quickly become misshapen unless backed by a piece of card.

You will need

Pale blue card blank, 125mm (5in) square

Floral paper stuck on to pale blue card, 115mm (4½in) square

Gold crinkled foil stuck on to card 50mm (2in) square

Tracing paper and pencil

Thick gold embroidery thread and a darning needle

Five small flower eyelets the same colour as the flowers on the paper

Craft knife, cutting mat, metal ruler and cuticle scissors

Eyelet tool kit

Glue stick

3D foam squares

Sticky tape

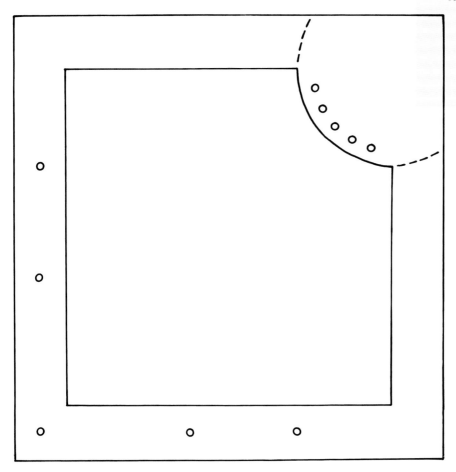

The template for the card, shown full size.

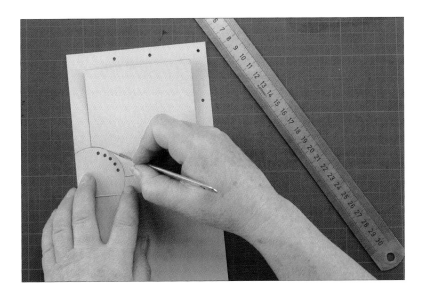

1. Transfer the template on to your card blank. Use the eyelet piercing tool to punch holes where indicated. Carefully cut out the centre square and part of the sun using your craft knife and cutting mat.

2. Insert the five flower eyelets in to the holes in the border, then set them. Thread the embroidery silk through the holes, starting with the top hole in the sun and going across to the top hole in the border. Continue as shown. Secure both ends using sticky tape.

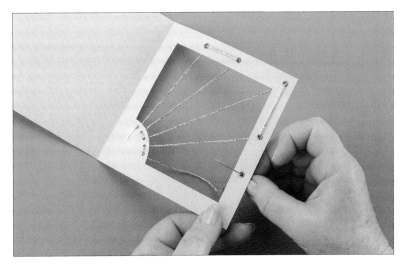

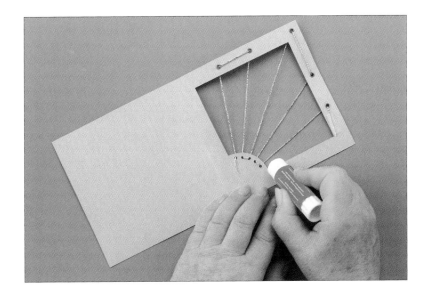

3. On the inside of the card, carefully apply glue stick to the internal edges of the square and sun.

4. Press the card with the floral paper stuck to it face down on to the card so that the floral side will show through the aperture. Make sure you cover the backs of the eyelets.

5. Transfer the sun part of the template on to the back of the gold foil-covered card, and cut it out.

Tip
When cutting out circles, curved cuticle scissors are easier to use and make a smoother cut.

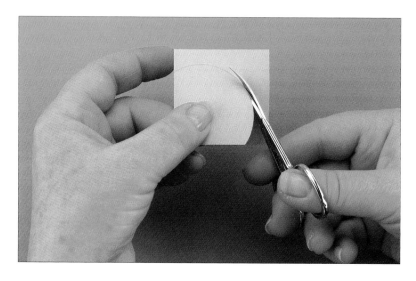

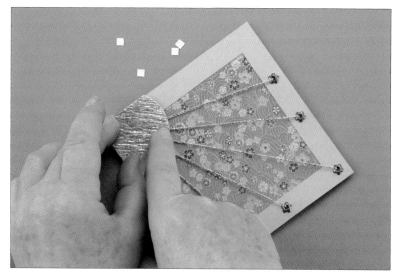

6. Attach four 3D foam squares to the back of the sun and position it over the threaded sun on the card.

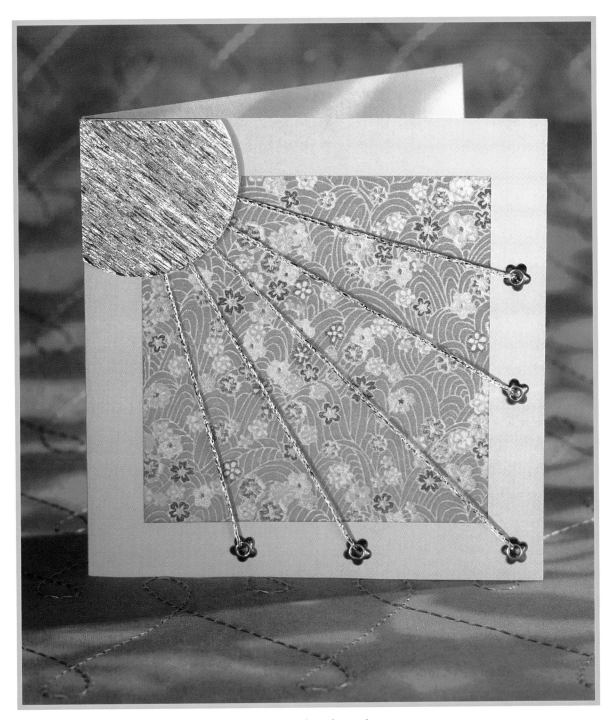

The finished card. I have tried to replicate the little flowers on this gift wrap by using a similar colour in the flower eyelets. The embroidery silk is gold-coloured thread with a fine foil twisted into it.

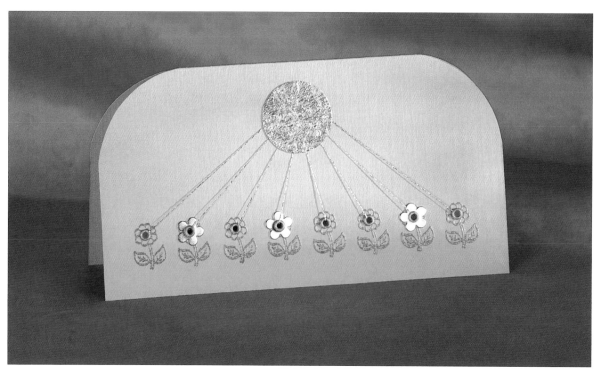

All these flowers have eyelet centres. The gold for this sun was a chocolate wrapper, scrunched up then smoothed out and stuck on to card. The little flowers were stamped and embossed to give slightly raised images. Three flower eyelets were included to add another gold dimension.

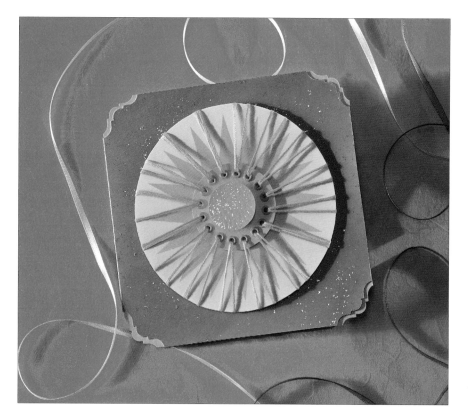

Glitter paint has been used here to add sparkle to the centre sun and blue background. The corners were cut using fancy-edged craft scissors with inlays of yellow neatly stuck on the inside of the card.

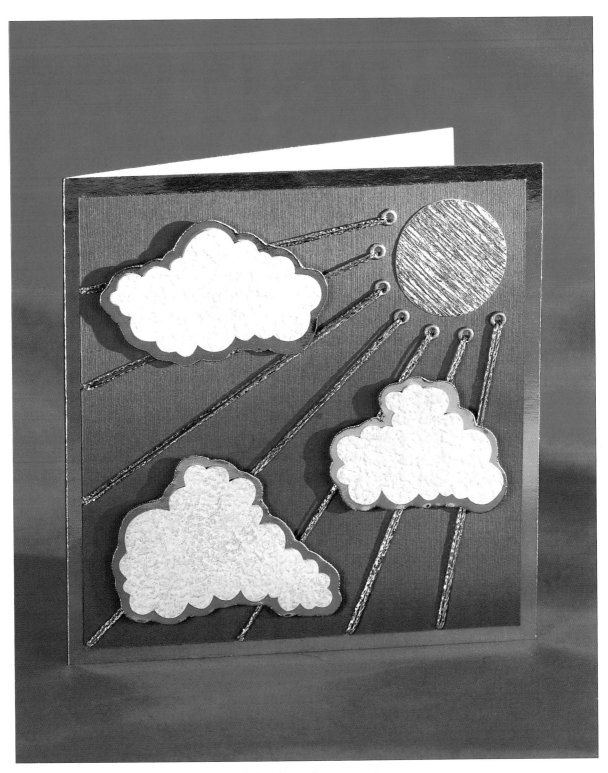

Every cloud has a silver lining. This would be an ideal card to send to someone in need of cheering up. The textured clouds were cut from a roll of wallpaper; they were lifted slightly to allow the gold and silver threads to run freely underneath. The blue card had little Vs cut along the edge to catch the threads before taking them up to the next eyelet.

Index

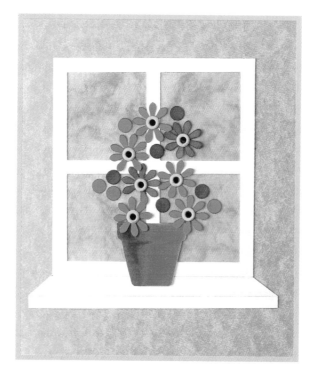

The sky through this little window is air mail writing paper (a rare commodity in these days of text and email). The plant pot was a photograph cut from a garden magazine.